Hannah!

To my Sweet child Hannah
(You will always be my sweet child Hannah)
It is my hope that the year ahead is
a kind one for you — that you can put
things behind you that belong there and you
can look ahead at an easier road
and a life you will feel good about. You
carry with you many of my best traits.
They will serve you well if you apply
them. My mantra since I got clean has
simply to Be honest — to be
myself and have faith. pretty
simple but a good way to
Be.

Love You forever
Dad

PATHWAYS

PUBLISHED BY WILLOW CREEK PRESS, INC.
P.O. BOX 147, MINOCQUA, WISCONSIN 54548

Photo Credits
p4 © PedroQuintela1/500px; p6 © Kayo/Shutterstock; p9 © Rericha/500px; p10 © PHOTOCREO Michal Bednarek/Shutterstock; p13 © Cornelia Doerr/age fotostock; p14 GeorgosTsamakdas/500px; p17 © F. Herrmann/age fotostock; p18 © Marta Paniti/Shutterstock; p21 © Christopher Elwell/Shutterstock; p22 © iLongLoveKing/Shutterstock; p25 © samcmoore/500px; p26 © haveseen/Shutterstock; p29 © Craig Tuttle/age fotostock; p30 © Thomas Herzog/500px; p33 © Michael Runkel/age fotostock; p34 © Peter Boehi/age fotostock; p37 © Ralph Reichert/age fotostock; p38 © Dennis van de Water/Shutterstock; p41 © Massimo Squillace/age fotostock; p42 © John Ealing/age fotostock; p45 © TTstudio/age fotostock; p46 © Raveesh Ahuja/age fotostock; p49 © Martin Reiser/age fotostock; p50 © Zoonar/M.Wachala/age fotostock; p53 © Julien Garcia/age fotostock; p54 © woottigon/Shutterstock; p57 © Tim Hurst/Masterfile; p58 © Adam Hester/age fotostock; p61 © HÂkan Sandbring/Syd/age fotostock; p62 © Stuart Westmorland Ph/age fotostock; p65 © David Mendelsohn/Masterfile; p66 © Jacques Laurent/age fotostock; p69 © Fabio Muzzi/age fotostock; p70 © Jacek Kadaj/age fotostock; p73 © Antonio Zimbone/age fotostock; p74 rui takada/500px; p77 © Chris Cheadle/age fotostock; p78 © Maciej Bledowski/500px; p81 © Olha Rohulya/500px; p82 © Corey Rich/Aurora O/age fotostock; p85 © Andrew Mayovskyy/Shutterstock; p86 © Gary Crabbe/age fotostock; p89 © Frank van Tol/age fotostock; p90 © Masterfile (Royalty-Free Division); © p93 Cody Duncan/age fotostock; p94 © worradirek/Shutterstock

PRINTED IN CHINA

PATHWAYS

WILLOW CREEK PRESS®

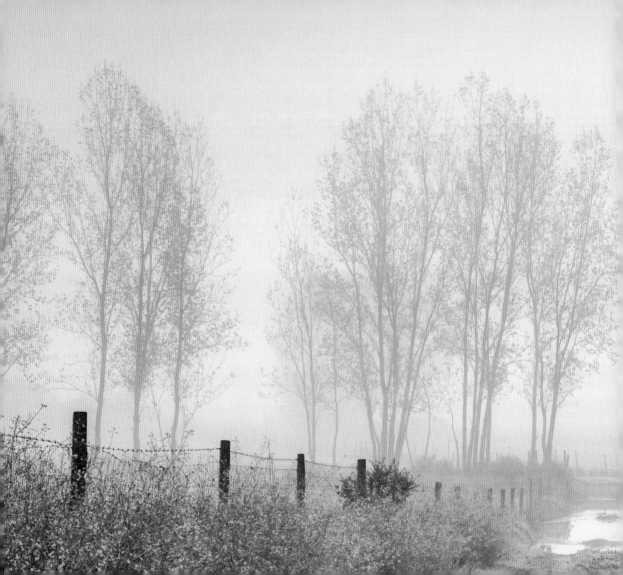

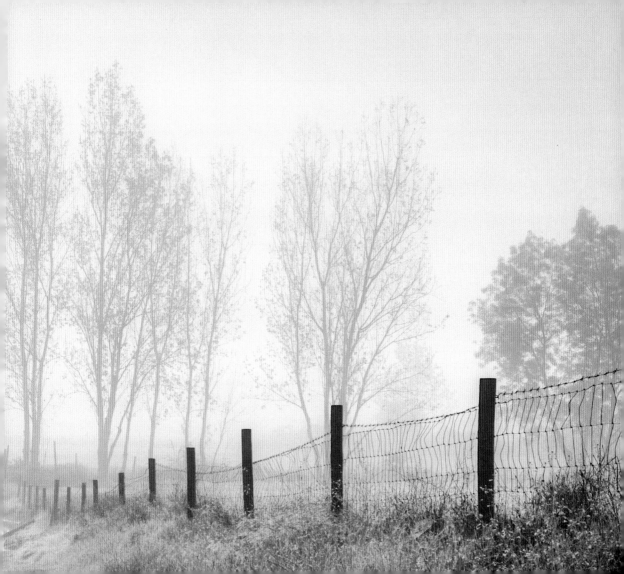

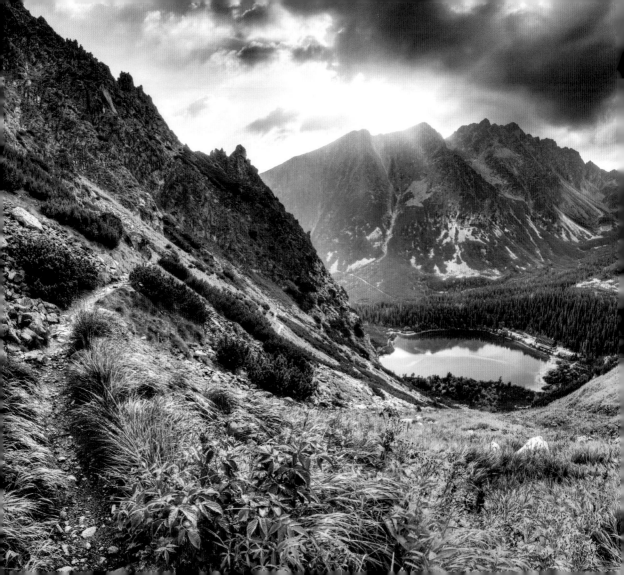

OVER EVERY MOUNTAIN THERE
IS A PATH, ALTHOUGH IT MAY
NOT BE SEEN FROM THE VALLEY.

—THEODOR ROETHKE

*D*O NOT GO WHERE THE PATH MAY LEAD,
GO INSTEAD WHERE THERE IS NO
PATH AND LEAVE A TRAIL.

—RALPH WALDO EMERSON

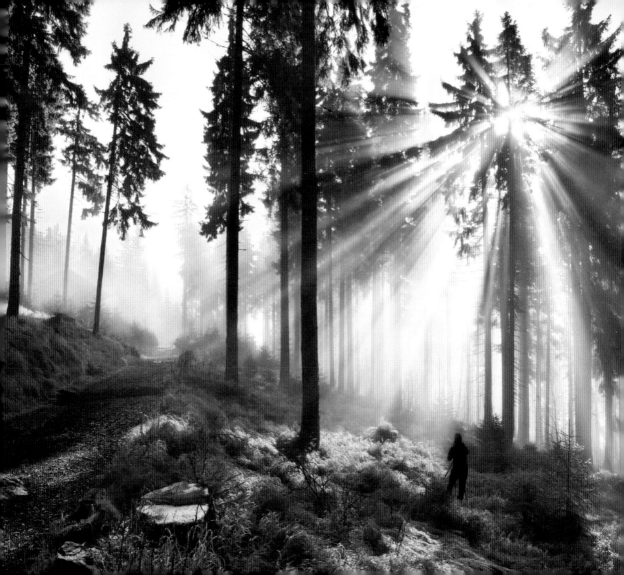

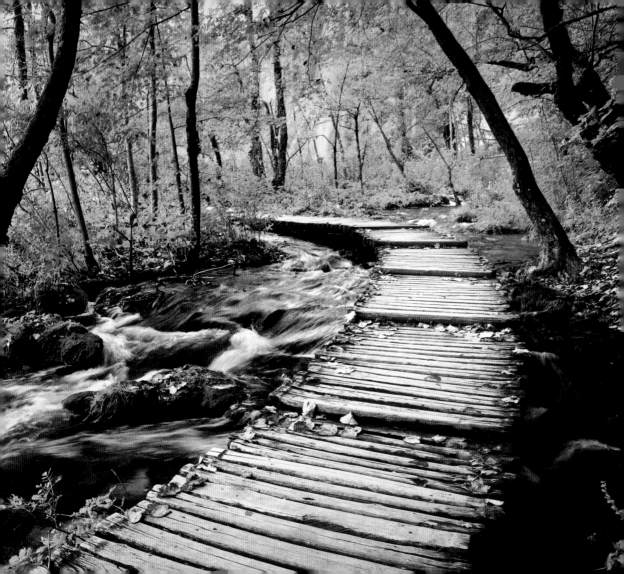

LIFE IS FULL OF ADVENTURE. THERE'S
NO SUCH THING AS A CLEAR PATHWAY.

—GUY LALIBERTE

HAVING NO DESTINATION I AM NEVER LOST.

—UNKNOWN

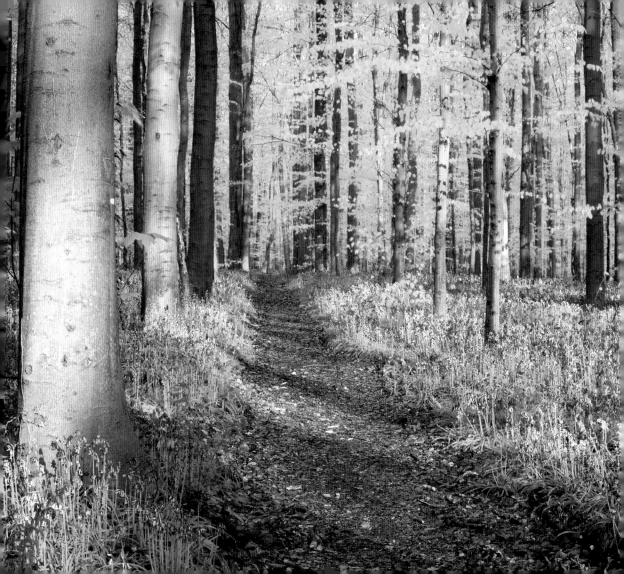

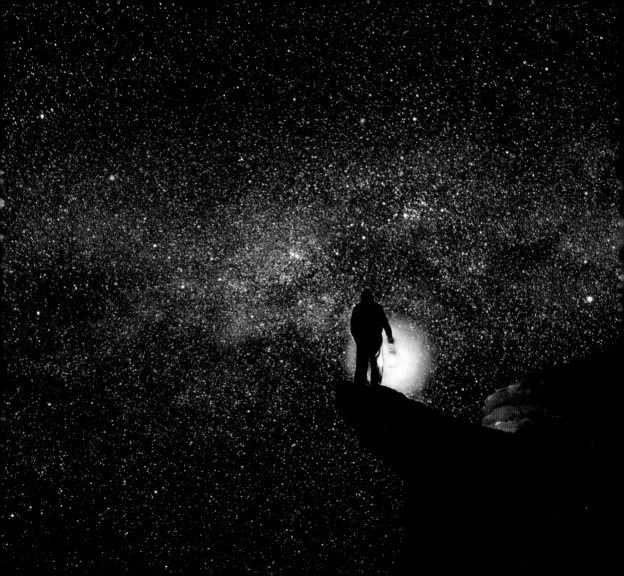

STARS ARE WHAT LIGHT THE
PATHWAY TO YOUR DREAMS.

—ANTHONY T. HINCKS

DON'T BE PUSHED BY YOUR PROBLEMS.

BE LED BY YOUR DREAMS.

—RALPH WALDO EMERSON

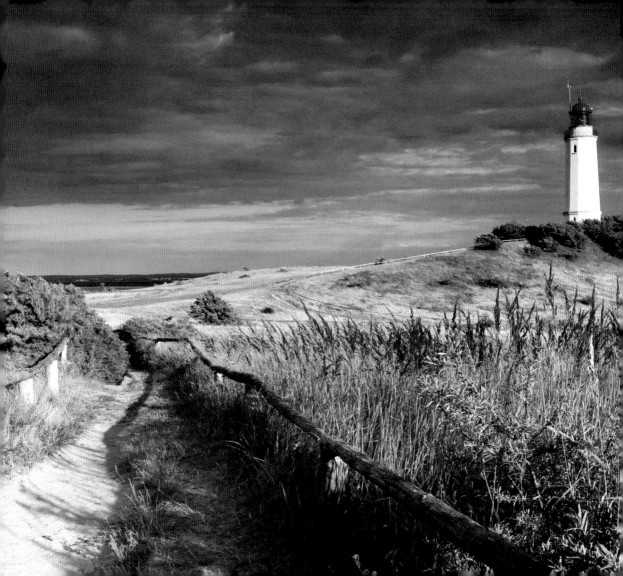

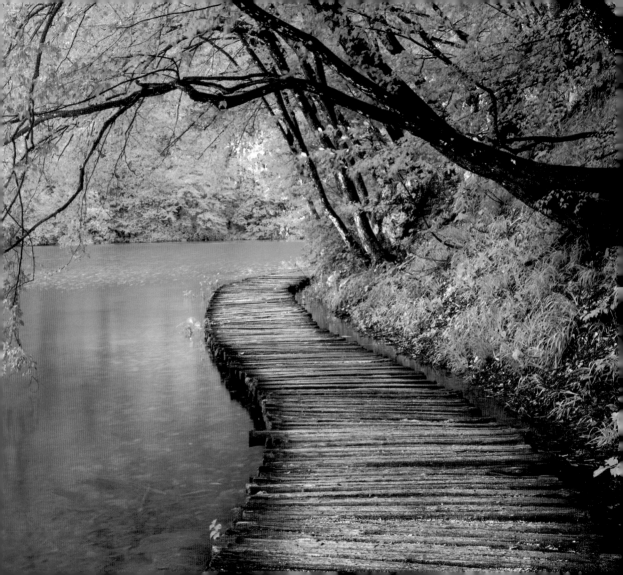

LIFE IS A JOURNEY TO BE EXPERIENCED,
NOT A PROBLEM TO BE SOLVED.

—WINNIE THE POOH

BE BRAVE ENOUGH TO TRAVEL THE UNKNOWN PART, AND LEARN WHAT YOU ARE CAPABLE OF.

—RACHEL WOLCHIN

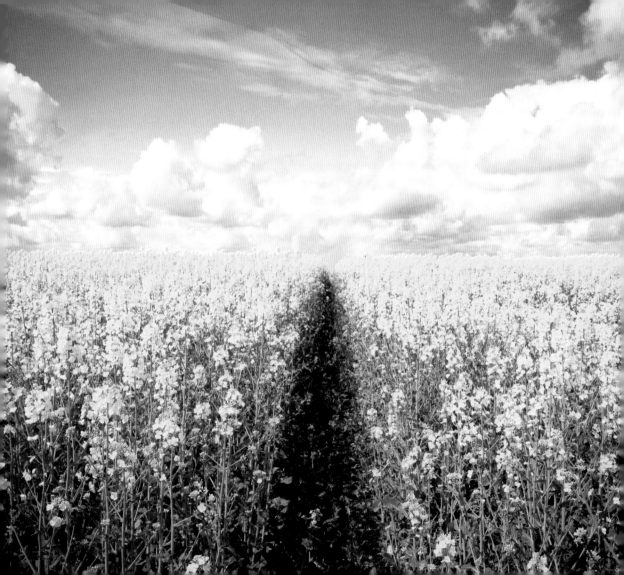

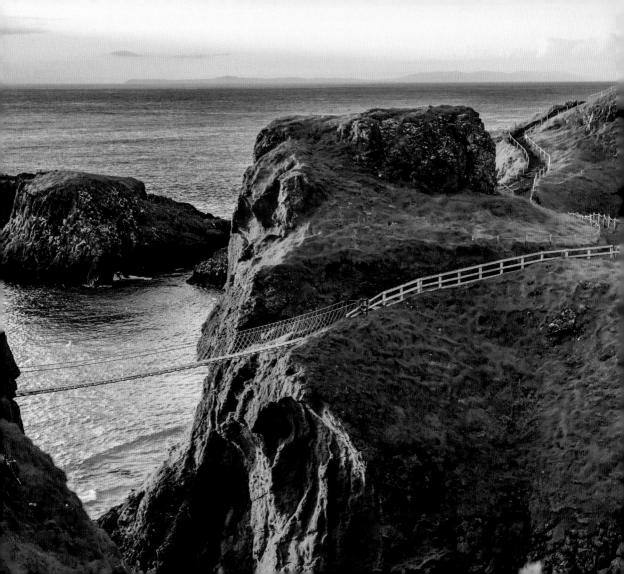

*I*F THERE IS NO WAY, CREATE ONE.

—UNKNOWN

OF ALL THE PATHS
YOU TAKE IN LIFE,
MAKE SURE A FEW OF
THEM ARE DIRT.

—JOHN MUIR

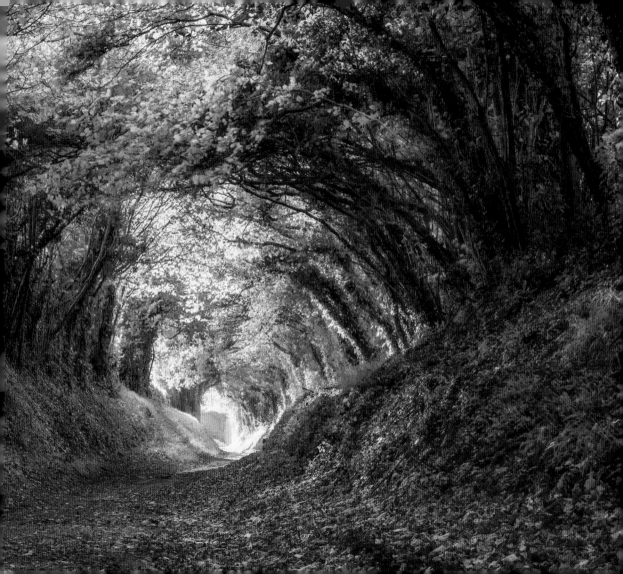

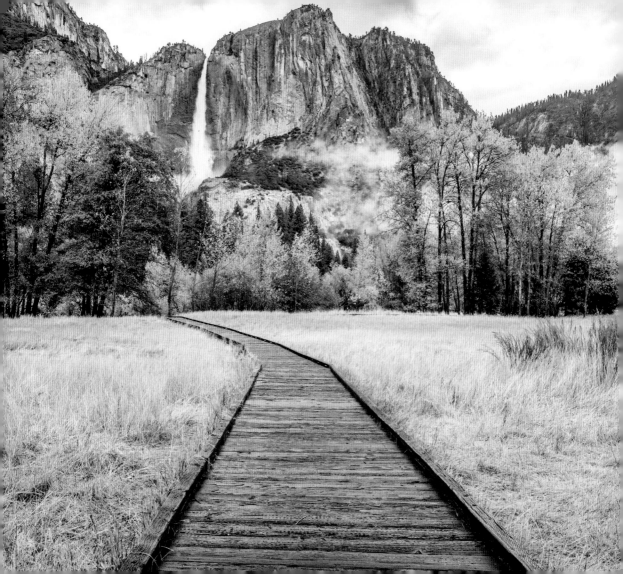

CREATE WHAT SETS YOUR HEART ON FIRE AND
IT WILL ILLUMINATE THE PATH AHEAD.

—UNKNOWN

*I*T'S NOT JUST A QUESTION OF CONQUERING A SUMMIT PREVIOUSLY UNKNOWN, BUT OF TRACING, STEP BY STEP, A NEW PATHWAY TO IT.

—GUSTAV MAHLER

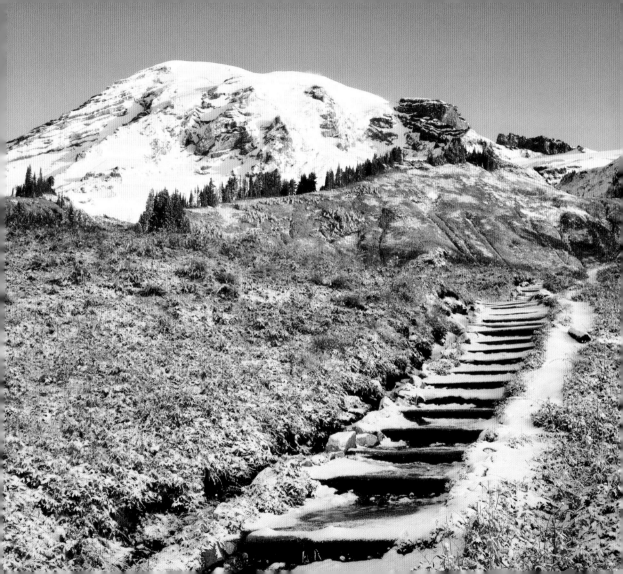

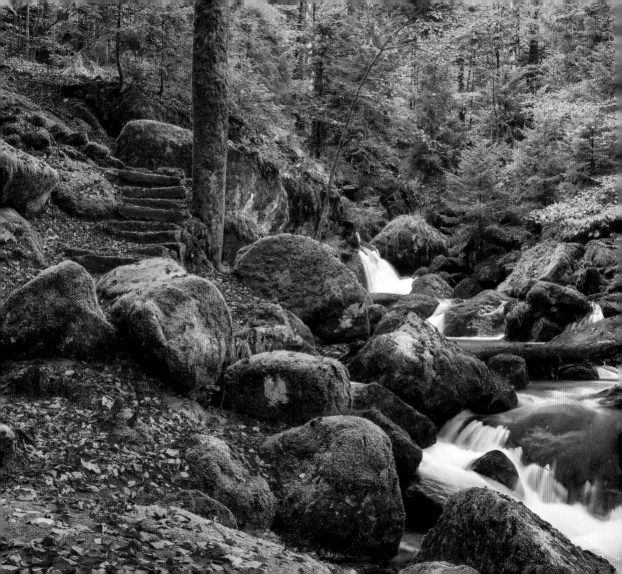

THE FIRST STEP TOWARDS GETTING
SOMEWHERE IS TO DECIDE THAT YOU ARE
NOT GOING TO STAY WHERE YOU ARE.

—UNKNOWN

MAN CANNOT DISCOVER NEW
OCEANS UNLESS HE HAS THE COURAGE
TO LOSE SIGHT OF THE SHORE.

—ANDRE GIDE

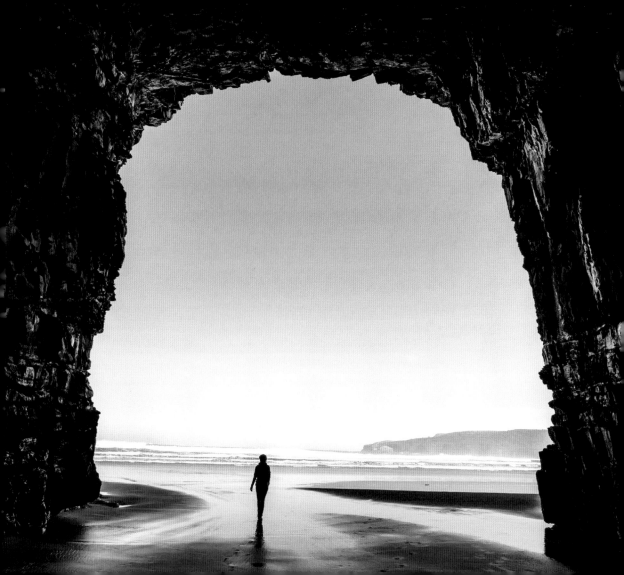

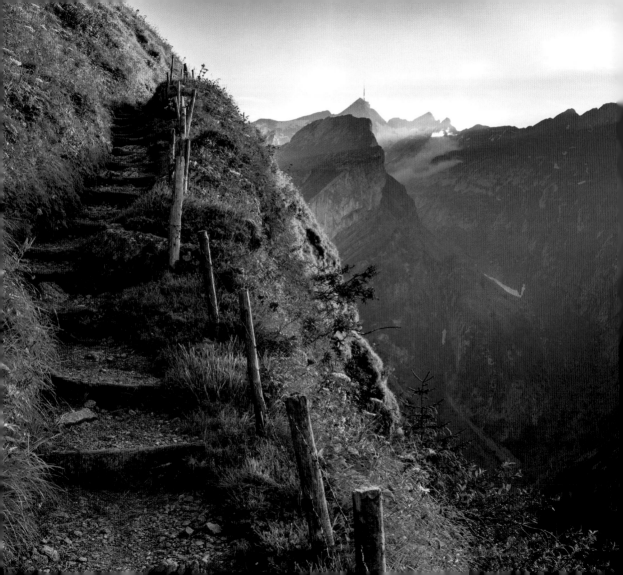

PURSUE SOME PATH, HOWEVER NARROW
AND CROOKED, IN WHICH YOU CAN
WALK WITH LOVE AND REVERENCE.

—HENRY DAVID THOREAU

*A*NYTHING'S POSSIBLE IF
YOU'VE GOT ENOUGH NERVE.

—J.K. ROWLINGS

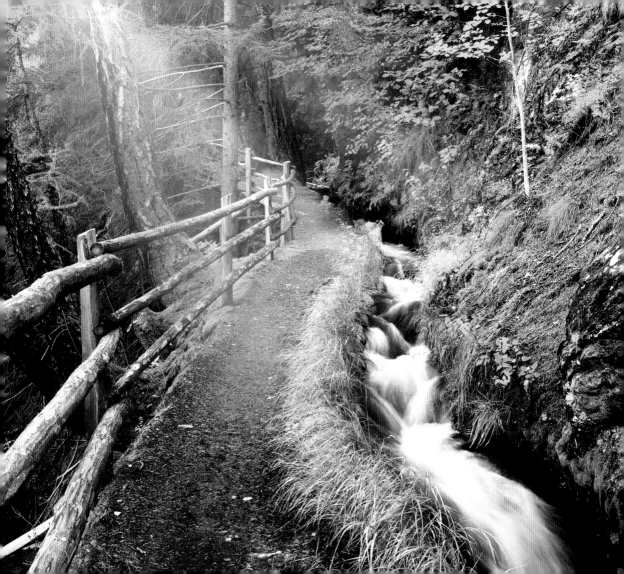

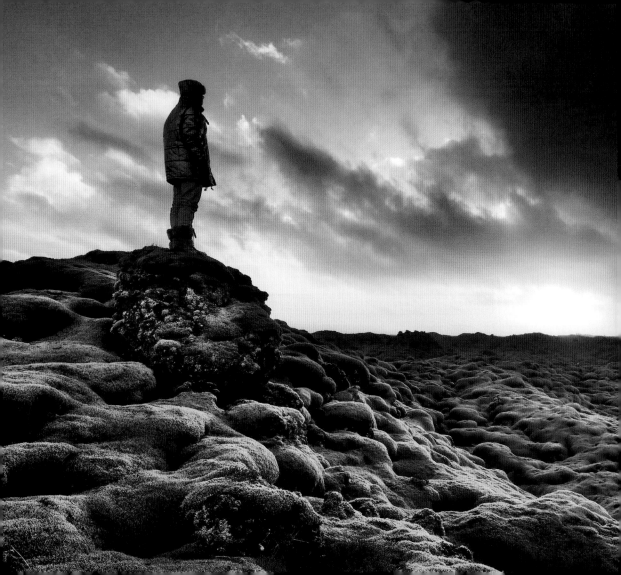

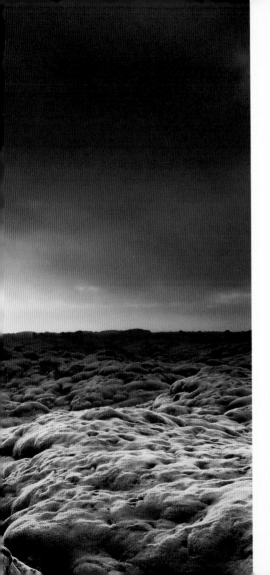

THE PATH IS MADE IN
THE WALKING OF IT.

—ZHUANGZI

TWO ROADS DIVERGED IN A WOOD
AND I—I TOOK THE ONE LESS TRAVELED BY,
AND THAT HAS MADE ALL THE DIFFERENCE.

—ROBERT FROST

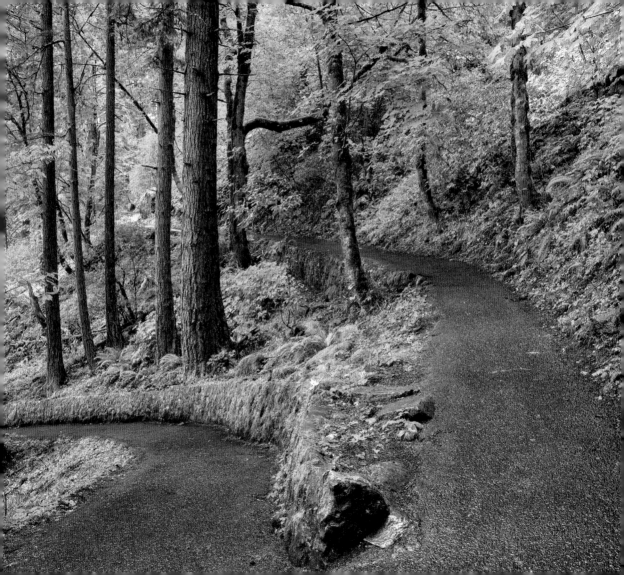

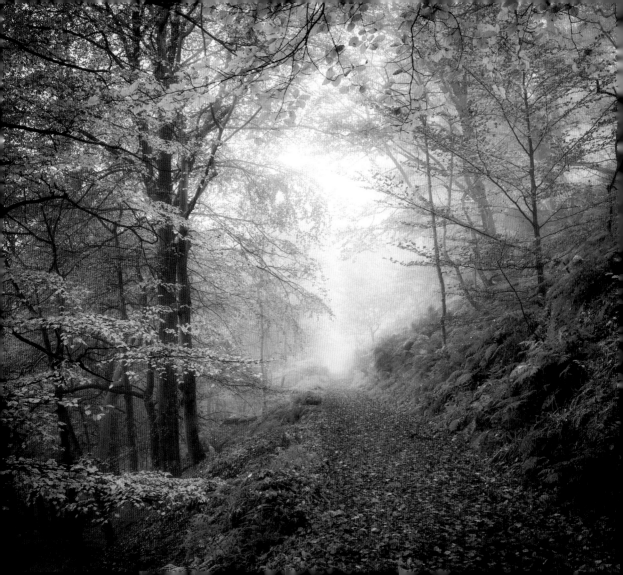

GO CONFIDENTLY IN THE DIRECTION OF YOUR
DREAMS. LIVE THE LIFE YOU HAVE IMAGINED.

—HENRY DAVID THOREAU

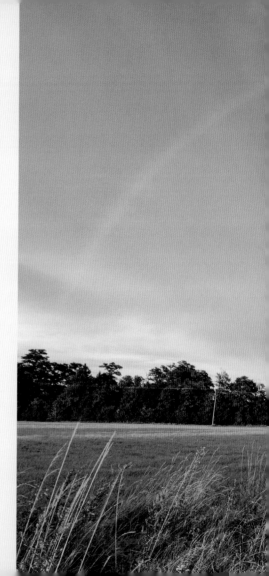

IT WON'T BE EASY, BUT
IT'LL BE WORTH IT.

—UNKNOWN

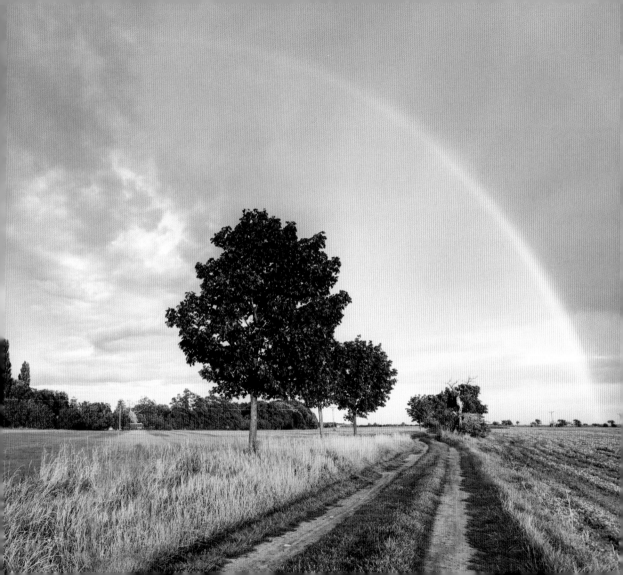

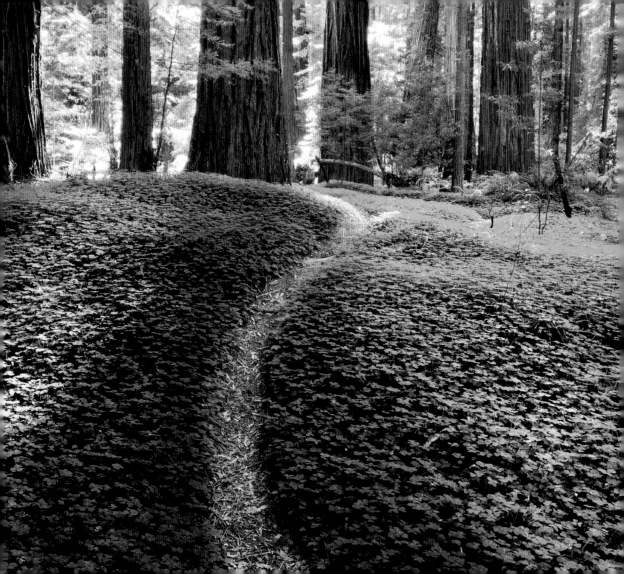

YOU MIGHT TAKE A LOT OF WRONG TURNS
BEFORE YOU FIND THE RIGHT PATH.

—UNKNOWN

DON'T FOLLOW THE PATH. BLAZE THE TRAIL.

—JORDAN BELFORT

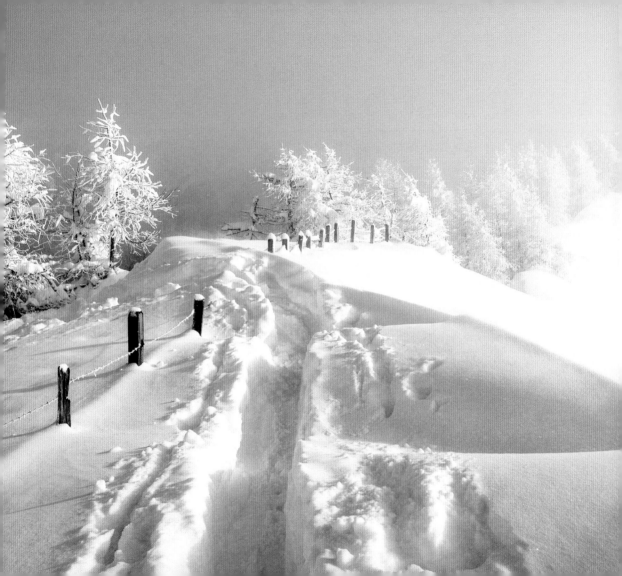

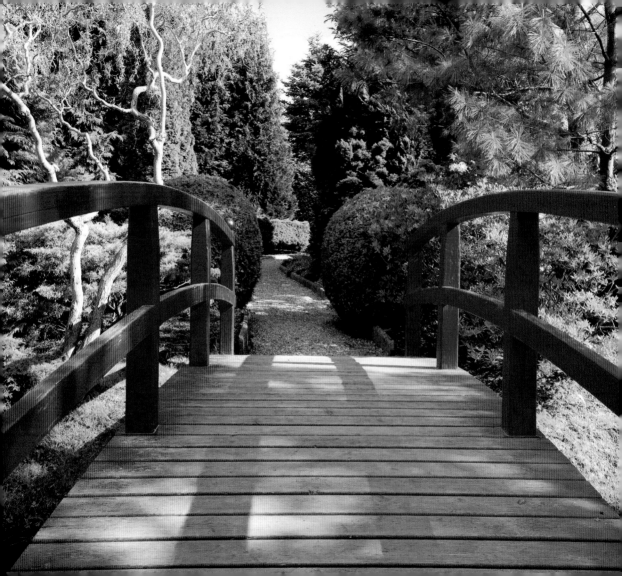

DOES THE WALKER CHOOSE THE
PATH, OR THE PATH THE WALKER?

—GARTH NIX

YOU DON'T HAVE TO SEE THE WHOLE
STAIRCASE, JUST TAKE THE FIRST STEP.
—MARTIN LUTHER KING

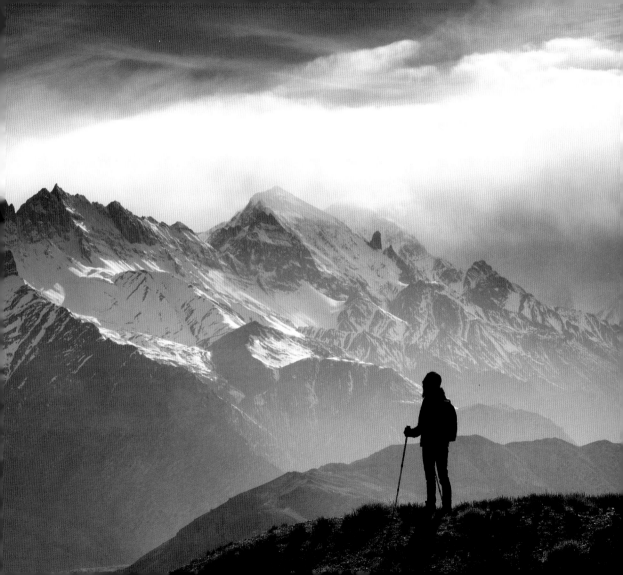

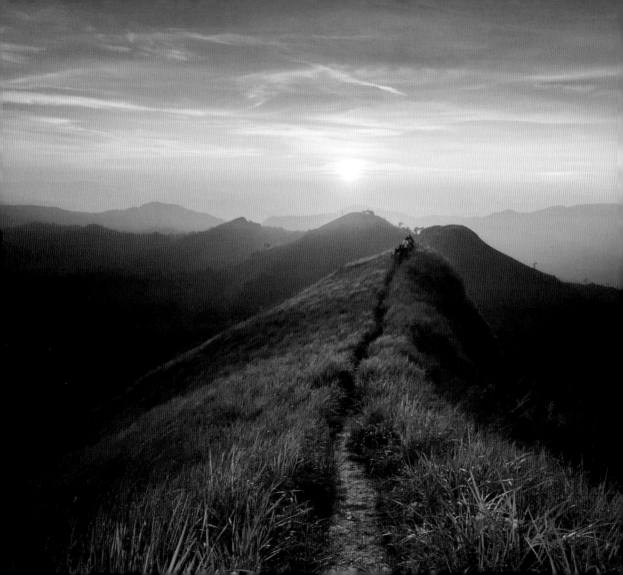

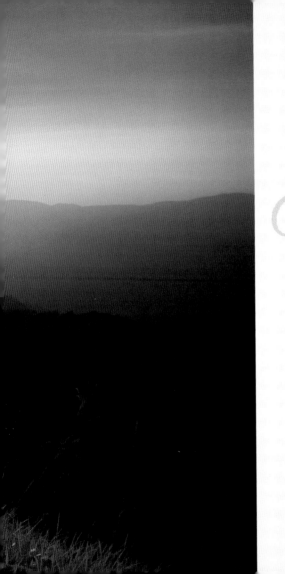

DIFFICULT ROADS OFTEN LEAD
TO BEAUTIFUL DESTINATIONS.

—UNKNOWN

SOMETIMES, EXPLORING IS
THE ONLY WAY TO FIND YOURSELF.

—KELLIE ELMORE

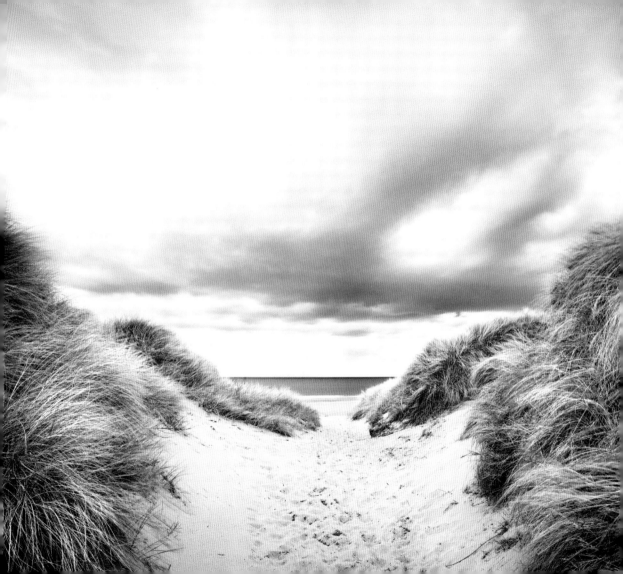

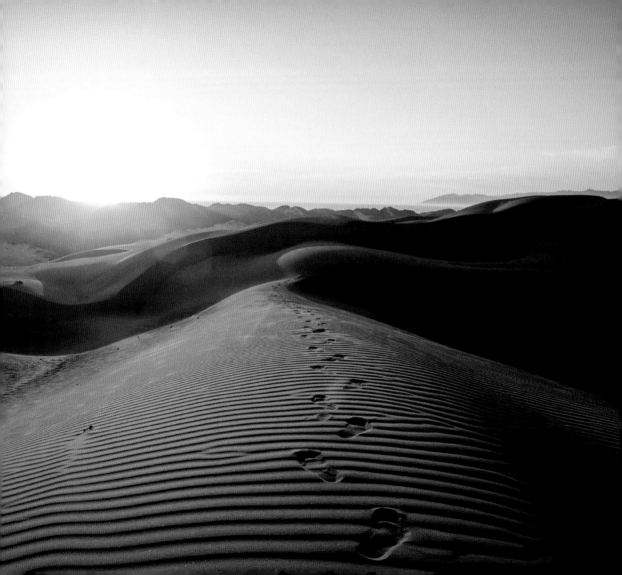

*I*F THE PATH BEFORE YOU IS CLEAR,
YOU'RE PROBABLY ON SOMEONE ELSE'S.

—JOSEPH CAMPBELL

MY PATH GETS MORE BEAUTIFUL
WHEN YOU WALK IT WITH ME.

—TONI SORENSON

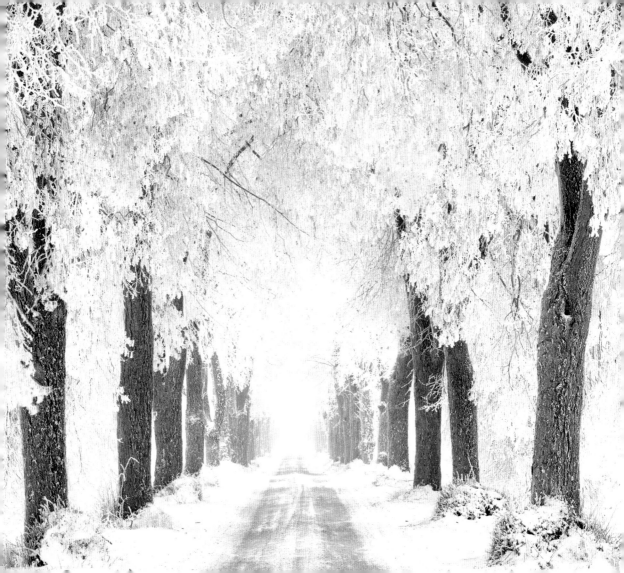

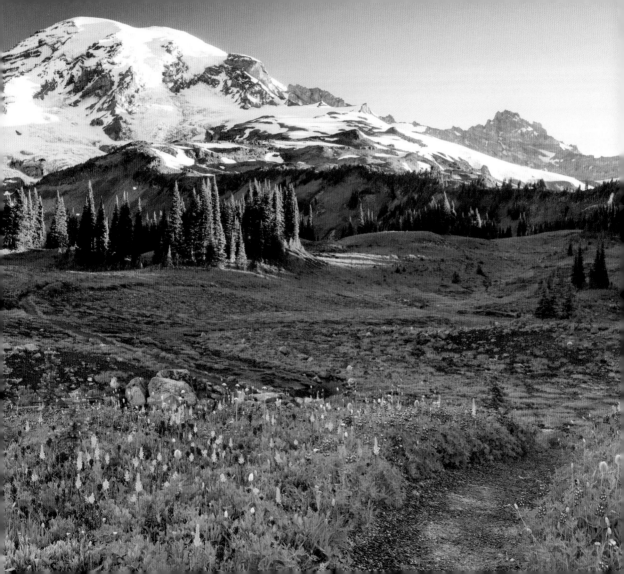

DIRECTION IS SO MUCH MORE IMPORTANT THAN
SPEED. MANY ARE GOING NOWHERE FAST.

—UNKNOWN

WALKING IS EASY... BUT IT REQUIRES
FAITH TO FIND THE RIGHT PATH.

—JOHN TWELVE HAWKS

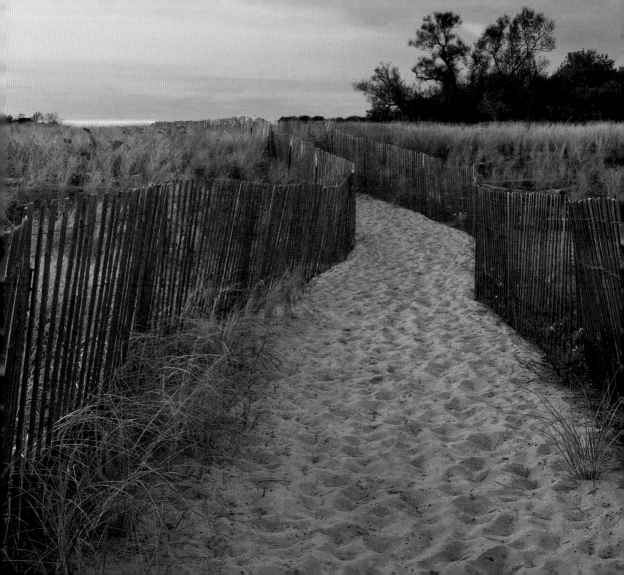

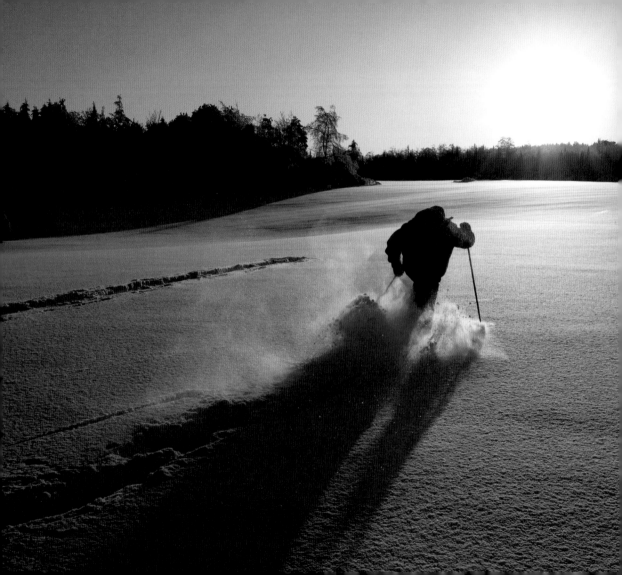

SOME BEAUTIFUL PATHS CAN'T BE
DISCOVERED WITHOUT GETTING LOST.

—EROL OZAN

ONE'S DESTINATION IS NEVER A PLACE,
BUT A NEW WAY OF SEEING THINGS.

—HENRY MILLER

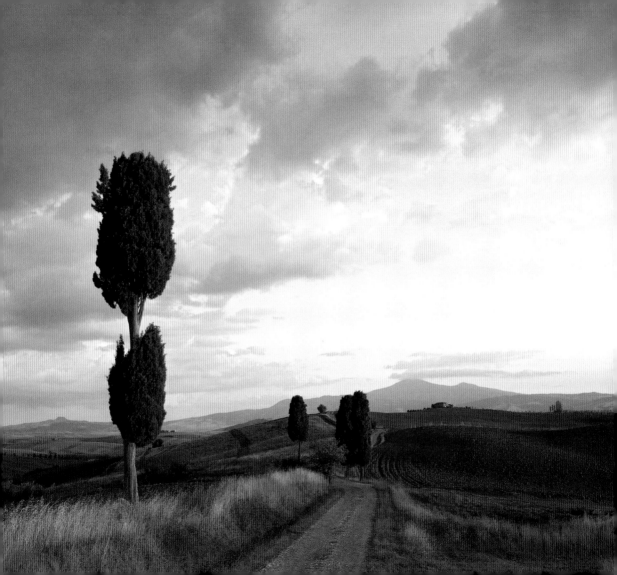

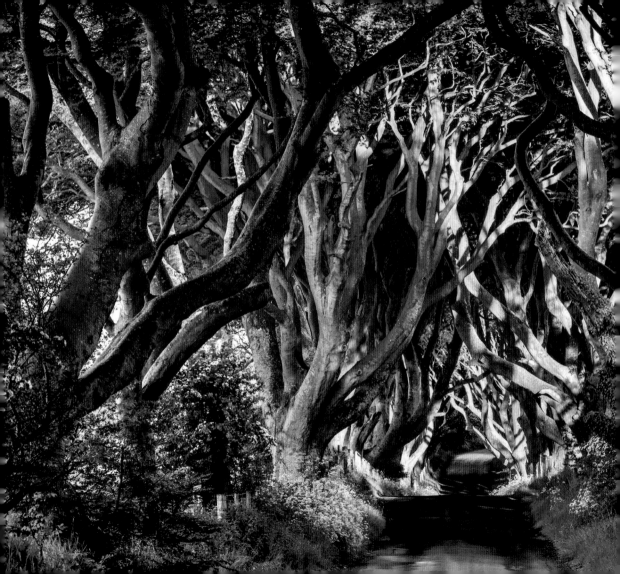

EVERY EXIT IS AN ENTRY
SOMEWHERE ELSE.

—TOM STOPPARD

NOT ALL STORMS COME TO DISRUPT YOUR
LIFE, SOME COME TO CLEAR YOUR PATH.

—UNKNOWN

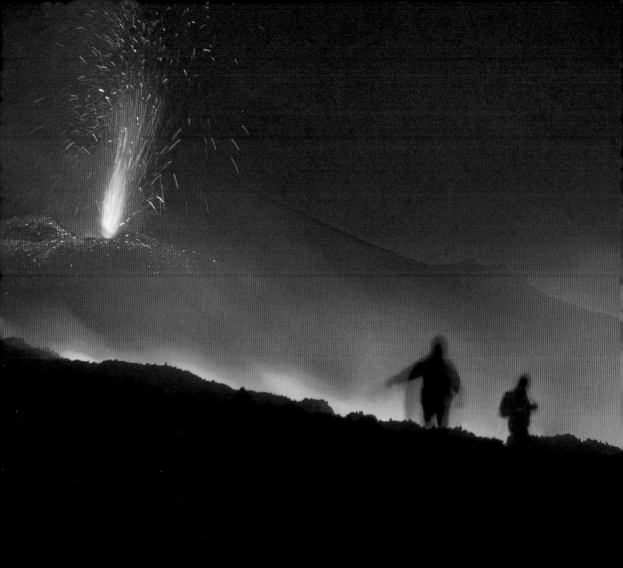

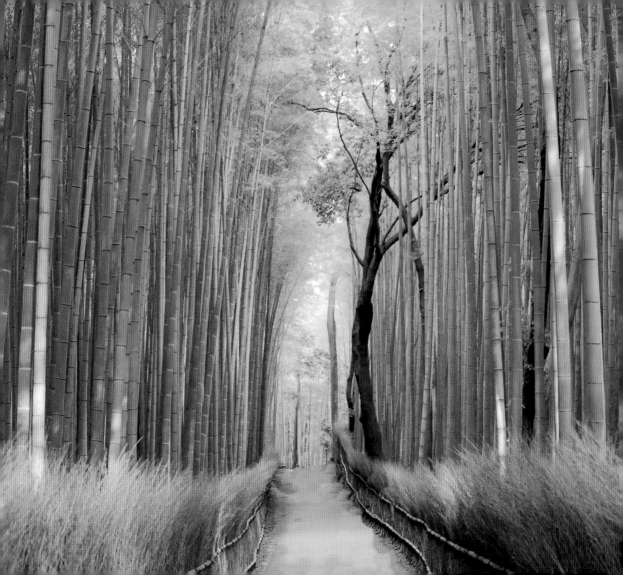

THERE ARE NO WRONG TURNINGS. ONLY PATHS
WE HAD NOT KNOWN WE WERE MEANT TO WALK.

—GUY GAVRIEL KAY

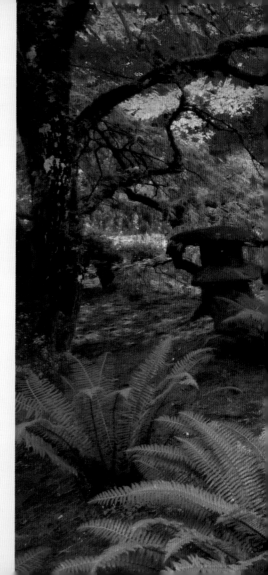

OBSTACLES DO NOT
BLOCK THE PATH,
THEY ARE THE PATH.

—ZEN PROVERB

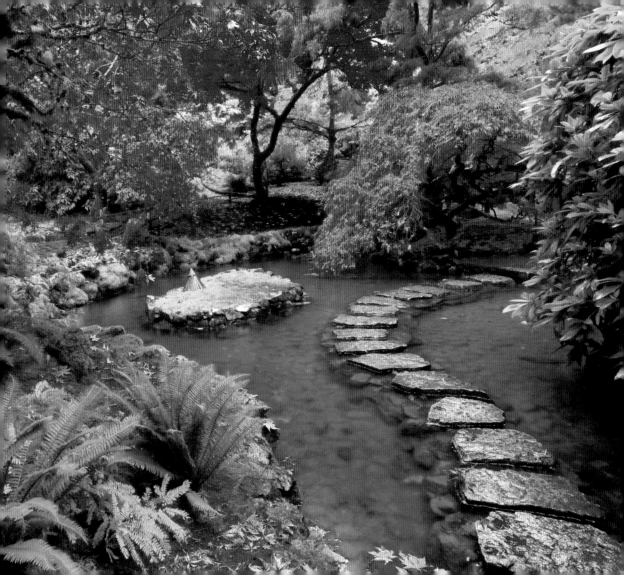

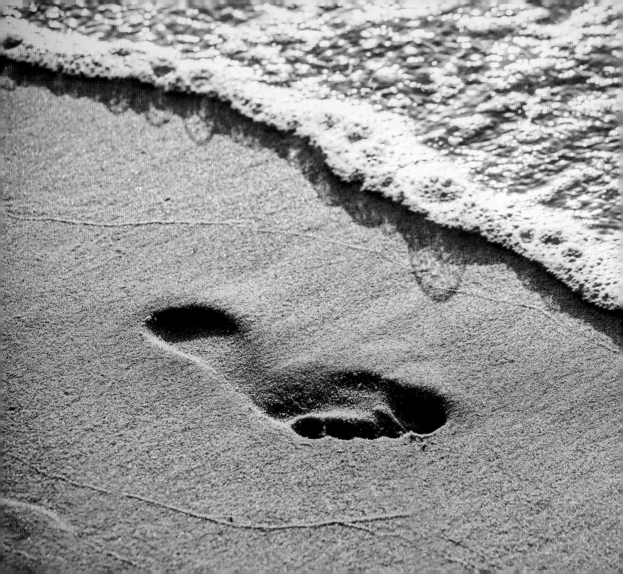

THE JOURNEY OF A THOUSAND
MILES BEGINS WITH ONE STEP.

—LAO TZU

*F*ORGET ABOUT TRYING TO COMPETE WITH
SOMEONE ELSE. CREATE YOUR OWN PATHWAY.
CREATE YOUR OWN NEW VISION.

—HERBIE HANCOCK

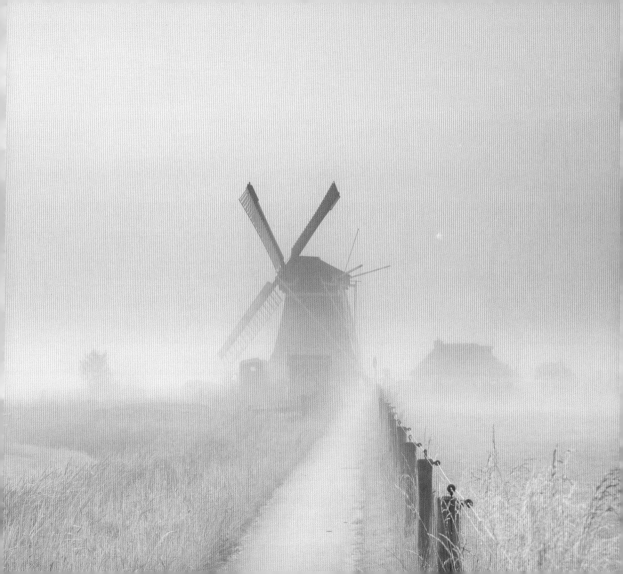

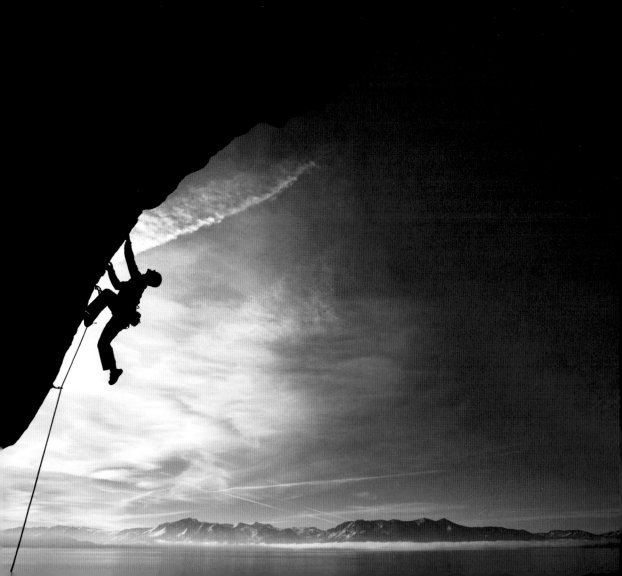

THE BLOCK OF GRANITE WHICH WAS AN
OBSTACLE IN THE PATHWAY OF THE WEAK,
BECAME A STEPPING-STONE IN THE
PATHWAY OF THE STRONG.

—THOMAS CARLYLE

TAKE ONLY MEMORIES, LEAVE ONLY FOOTPRINTS.

—CHIEF SEATTLE

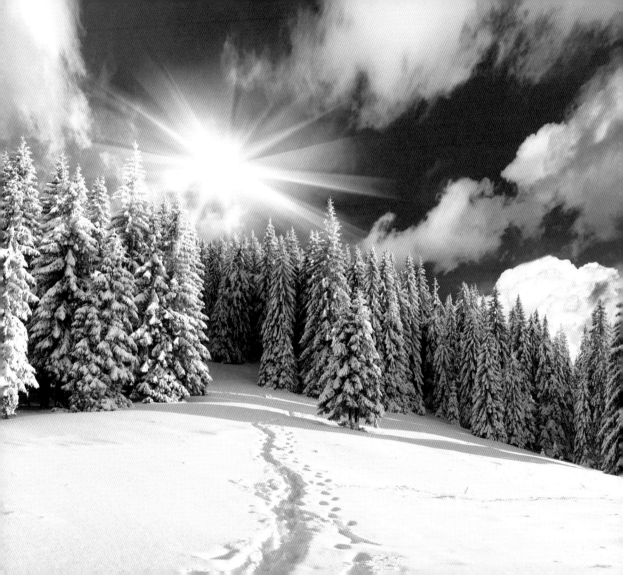

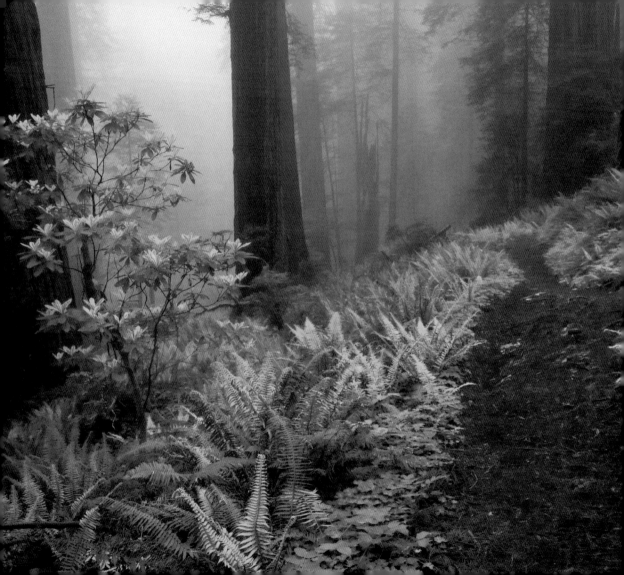

TRUE MORALITY CONSISTS NOT IN
FOLLOWING THE BEATEN TRACK,
BUT IN FINDING THE TRUE PATH FOR
OURSELVES, AND FEARLESSLY FOLLOWING IT.

—MAHATMA GANDHI

SET YOUR OWN PATH.

—UNKNOWN

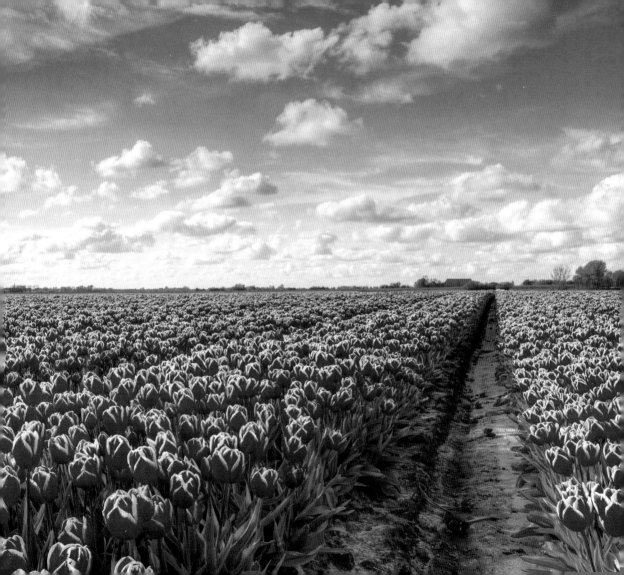

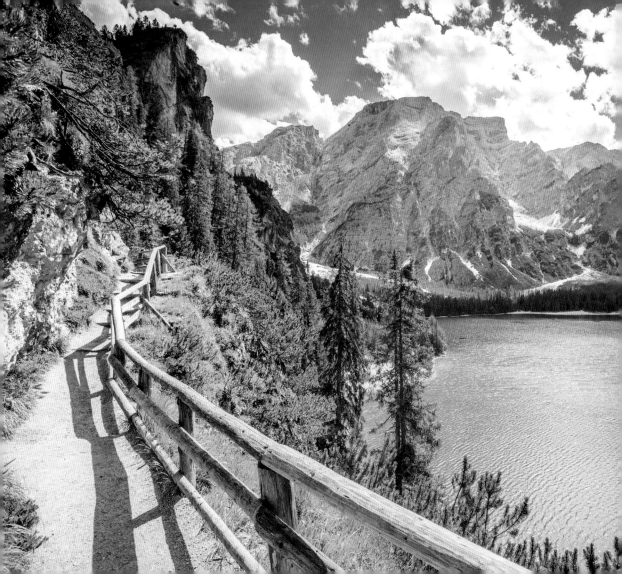

THERE ARE DIFFERENT PATHS TO YOUR DESTINATION. CHOOSE YOUR OWN PATH.

—LAILAH GIFTY AKITA

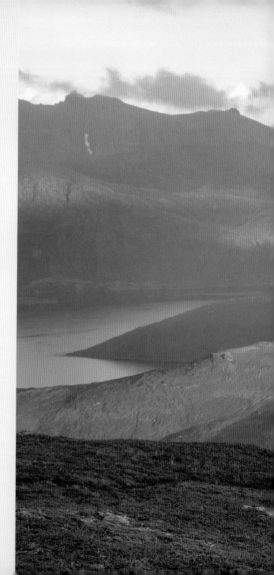

LIFE BEGINS AT THE END OF
YOUR COMFORT ZONE.

—NEALE DONALD WALSCH

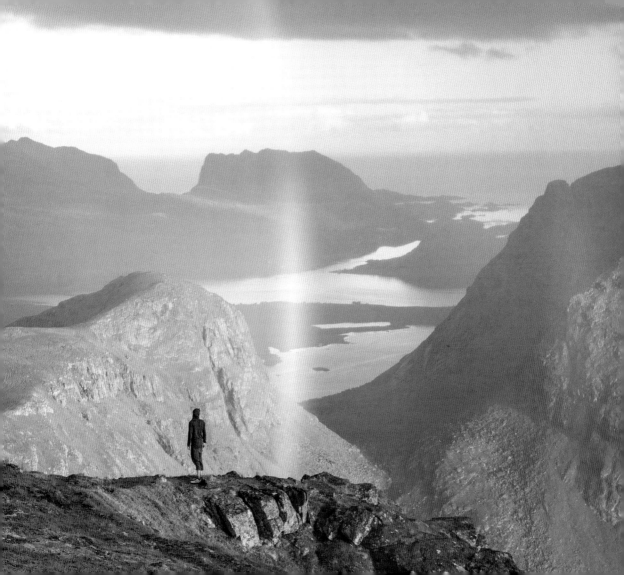

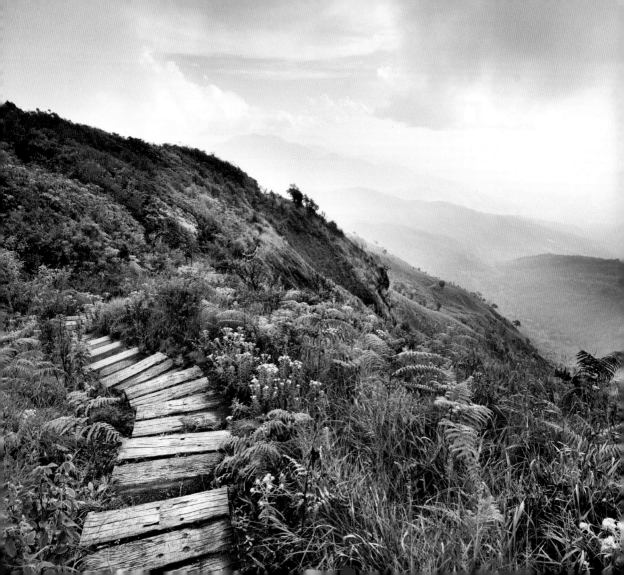

DON'T ALWAYS COMPLAIN THE WAY ISN'T THERE.
IF YOU CAN'T FIND THE WAY, CREATE IT.

—ISRAELMORE AYIVOR